Revelation for Kids

ISBN 979-8-88832-127-0 (paperback)
ISBN 979-8-88832-129-4 (hardback)
ISBN 979-8-88832-128-7 (digital)

Christian Faith Publishing
832 Park Avenue
Meadville, PA 16335
www.christianfaithpublishing.com

Printed in the United States of America

Revelation for Kids

WRITTEN BY SANDRA OLSON

ILLUSTRATED BY ZACH ORR

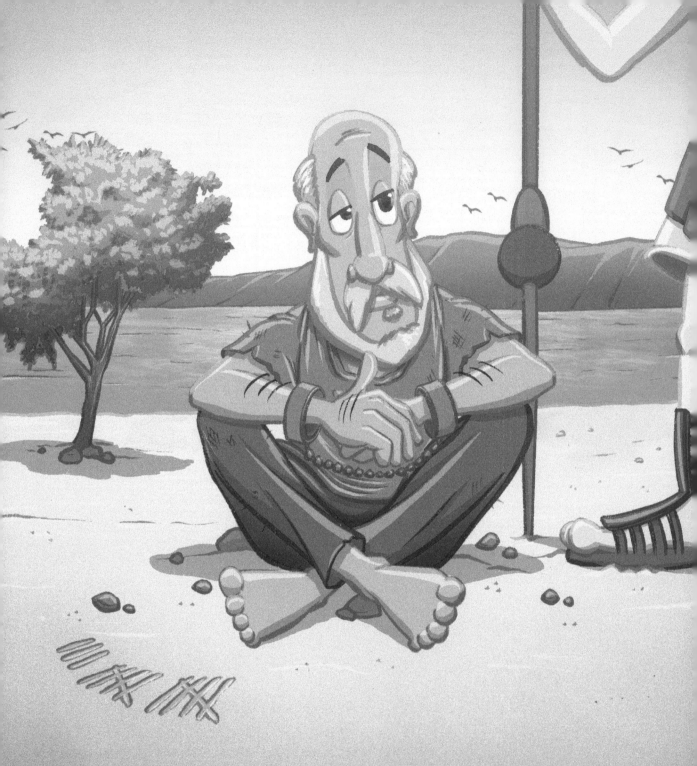

John, a disciple and best friend of Jesus, was sent to a prisoner's island called Patmos. He was sent there by an evil emperor for preaching the good news that Jesus was the Messiah!

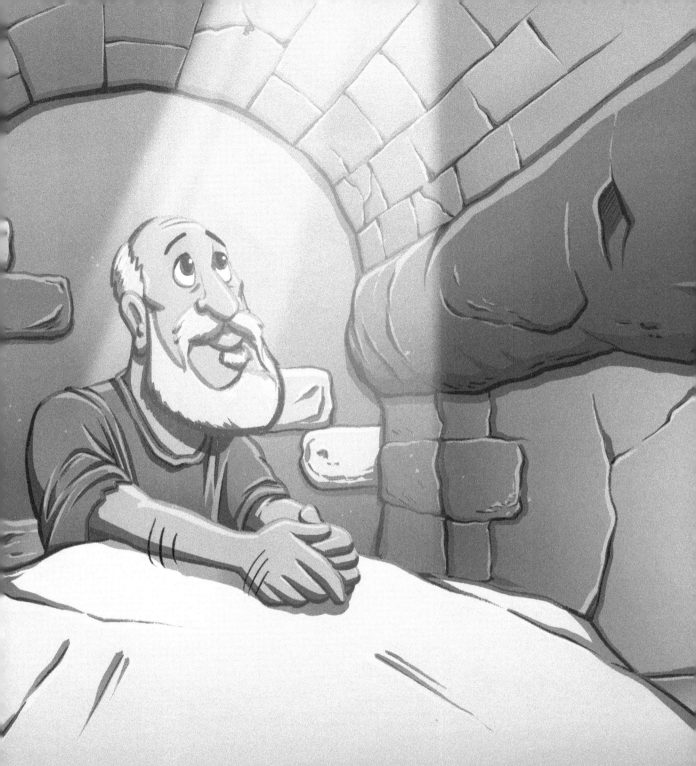

While John was on the island of Patmos, he continued to pray and worship God.

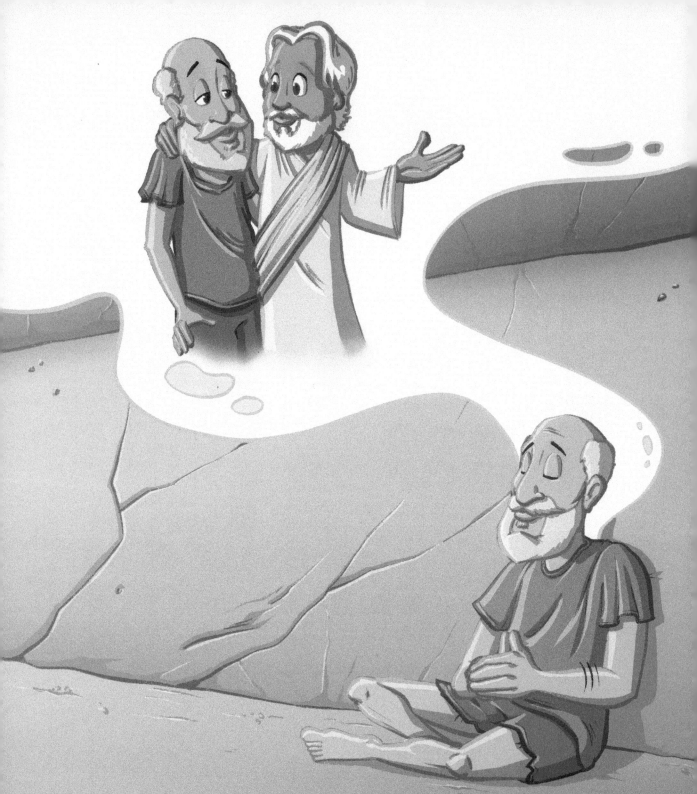

Even though Jesus was now in Heaven, John would get quiet and still to let the Holy Spirit inside of him speak with Jesus.

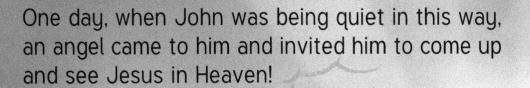

One day, when John was being quiet in this way, an angel came to him and invited him to come up and see Jesus in Heaven!

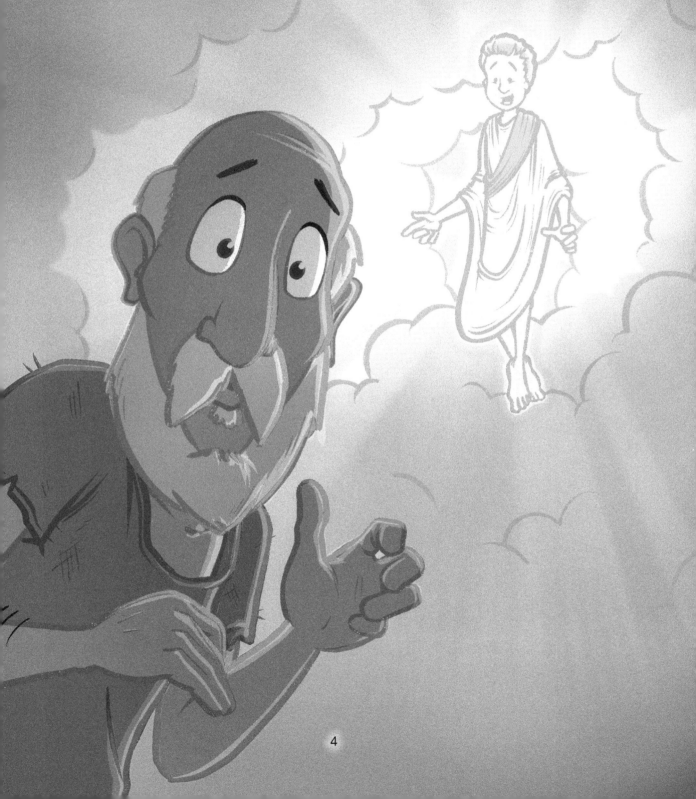

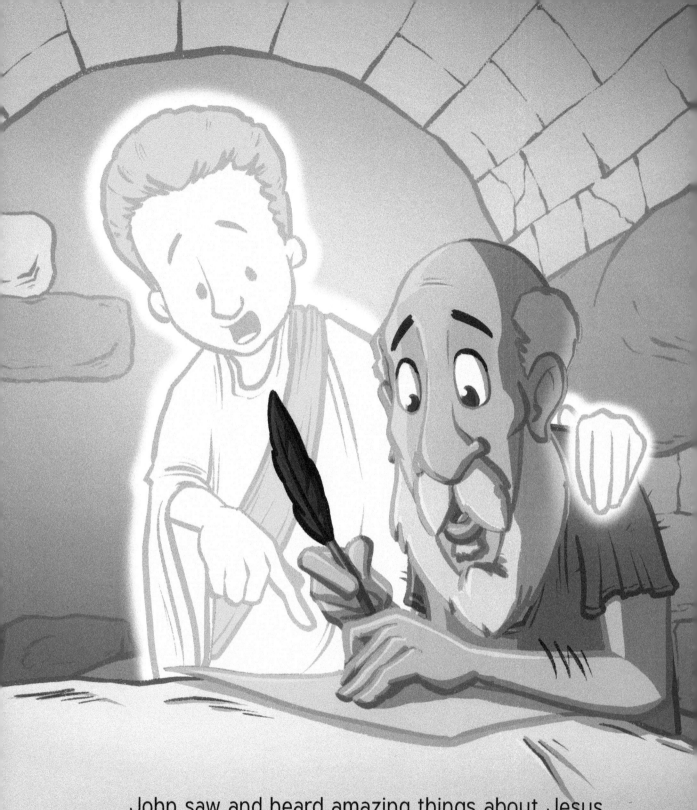

John saw and heard amazing things about Jesus
and what was going to happen in the future.
The angel told him to write it all down.

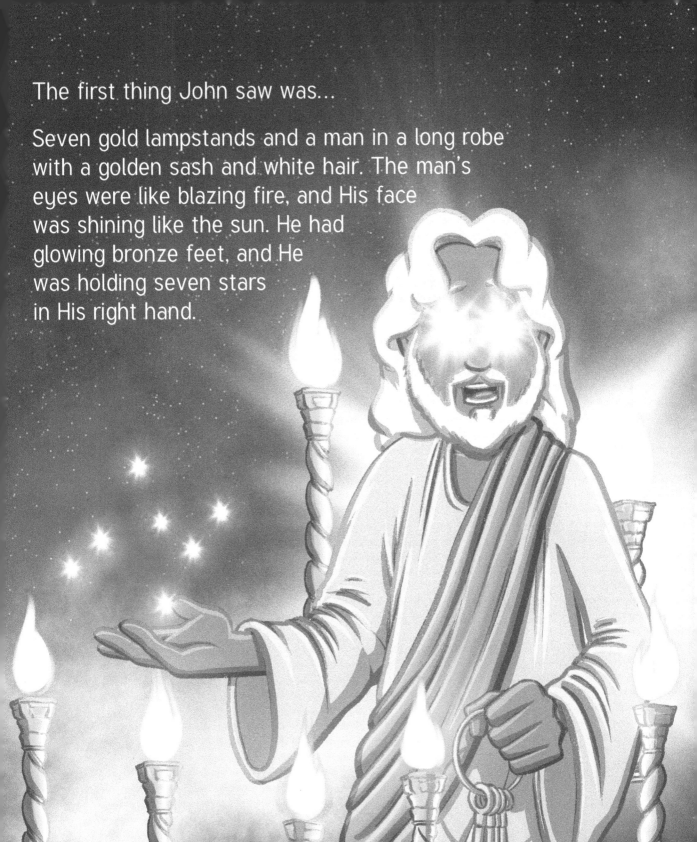

The first thing John saw was...

Seven gold lampstands and a man in a long robe with a golden sash and white hair. The man's eyes were like blazing fire, and His face was shining like the sun. He had glowing bronze feet, and He was holding seven stars in His right hand.

6

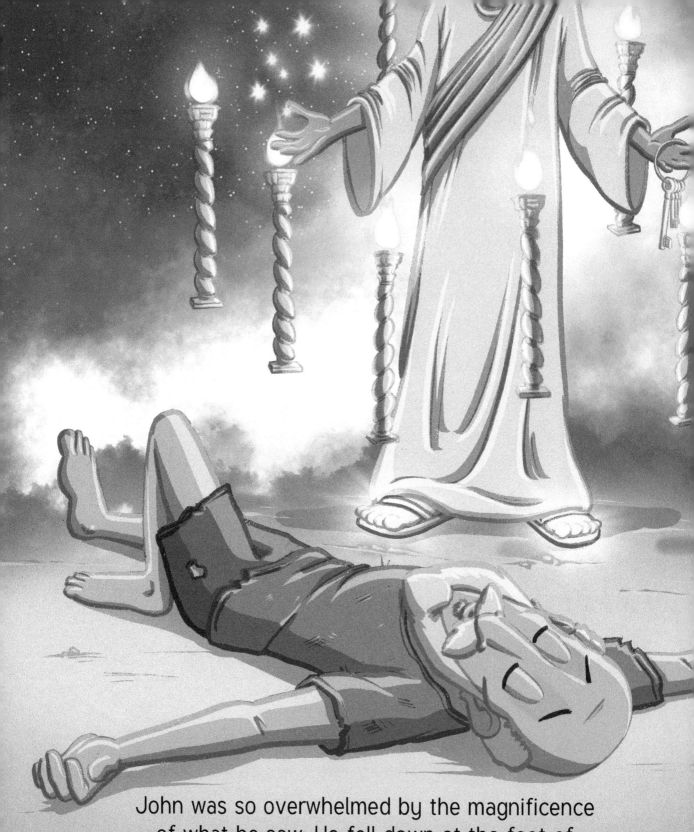

John was so overwhelmed by the magnificence
of what he saw. He fell down at the feet of
this man (who was Jesus) as if he died.

Then Jesus touched John with His right hand and told him, "Do not be afraid. I am the First and the Last. I am the Living One. I was dead, and behold, I am alive forever and ever, and I hold the keys of death and hell."

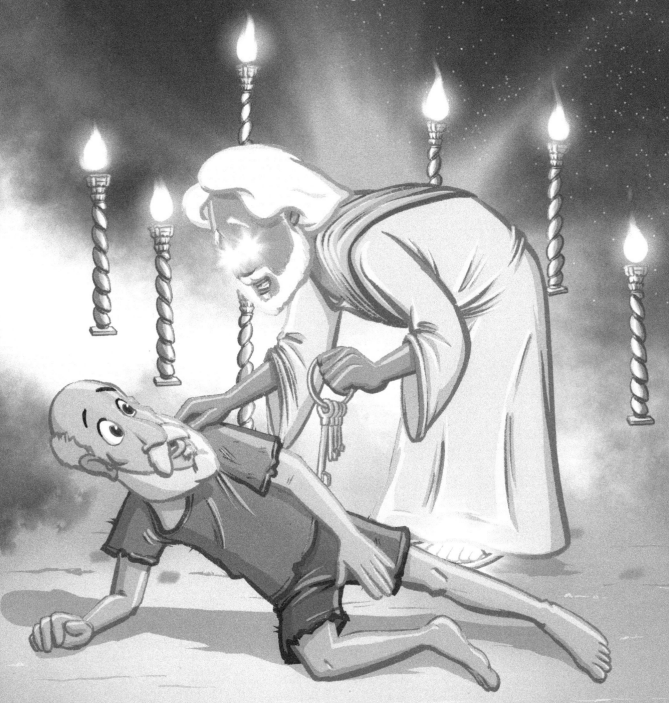

So John got up and began to write everything Jesus told him and showed him. First, he wrote letters to the churches that were close to the island of Patmos.

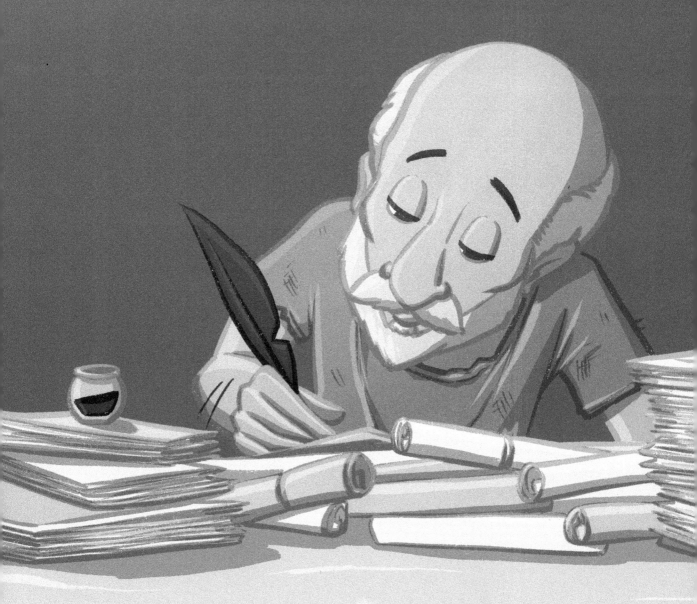

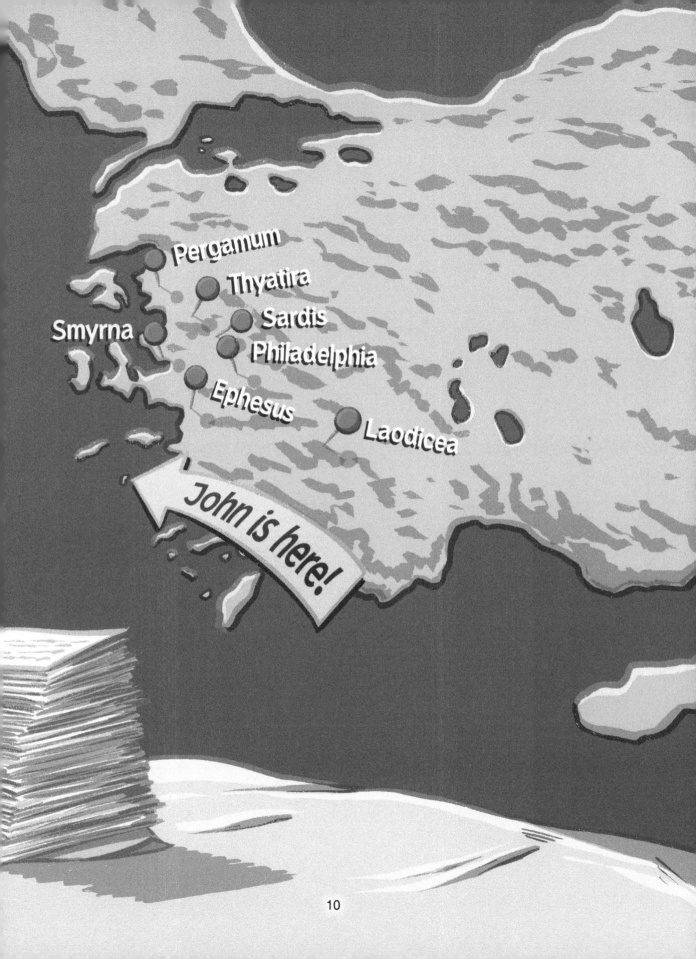

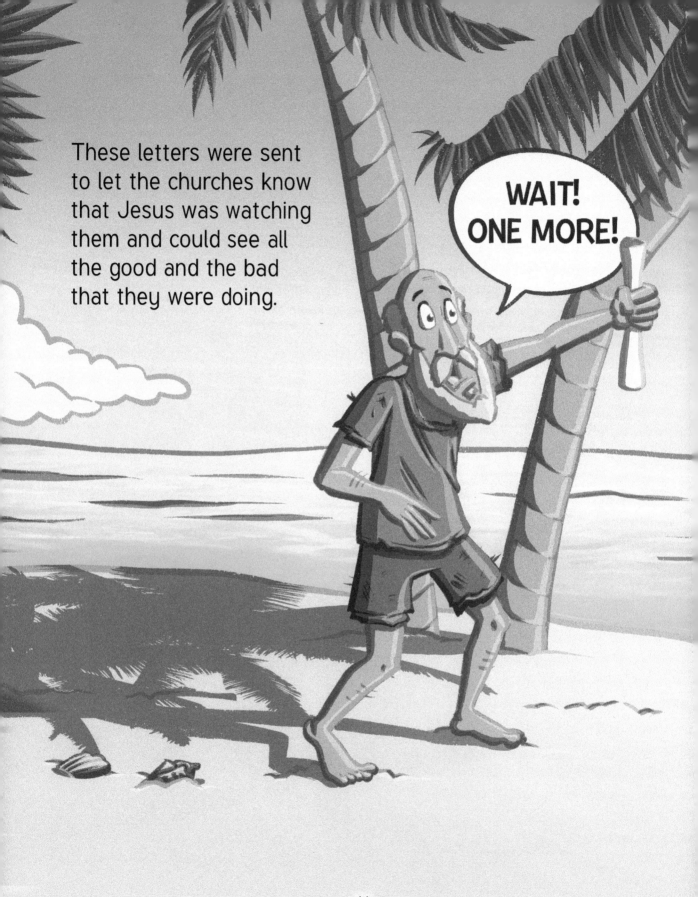

These letters were sent to let the churches know that Jesus was watching them and could see all the good and the bad that they were doing.

11

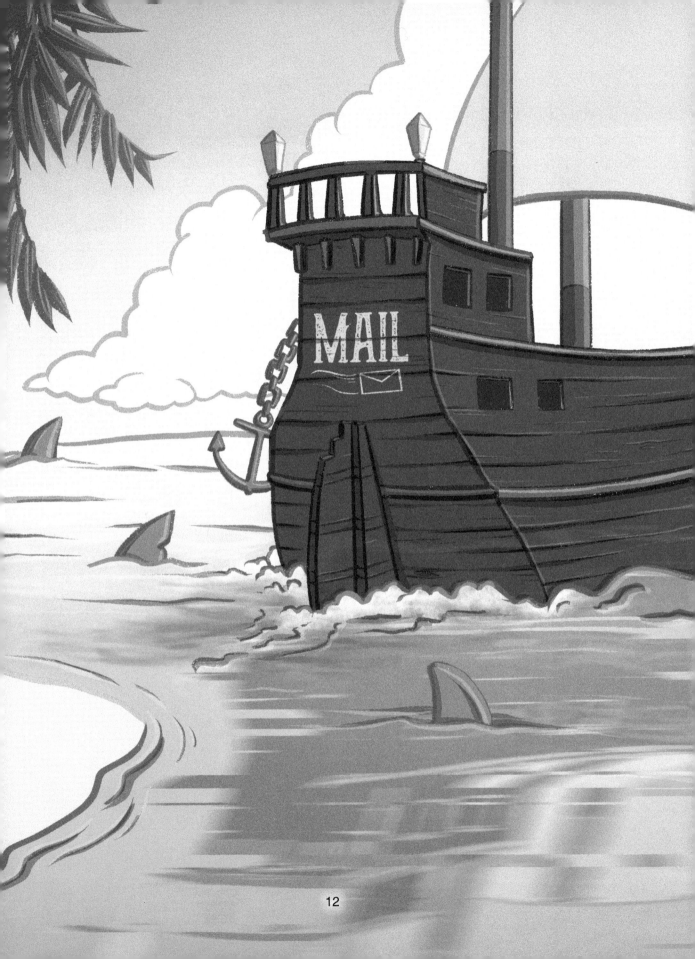

In these letters, Jesus encouraged them to keep doing good but stop doing bad.

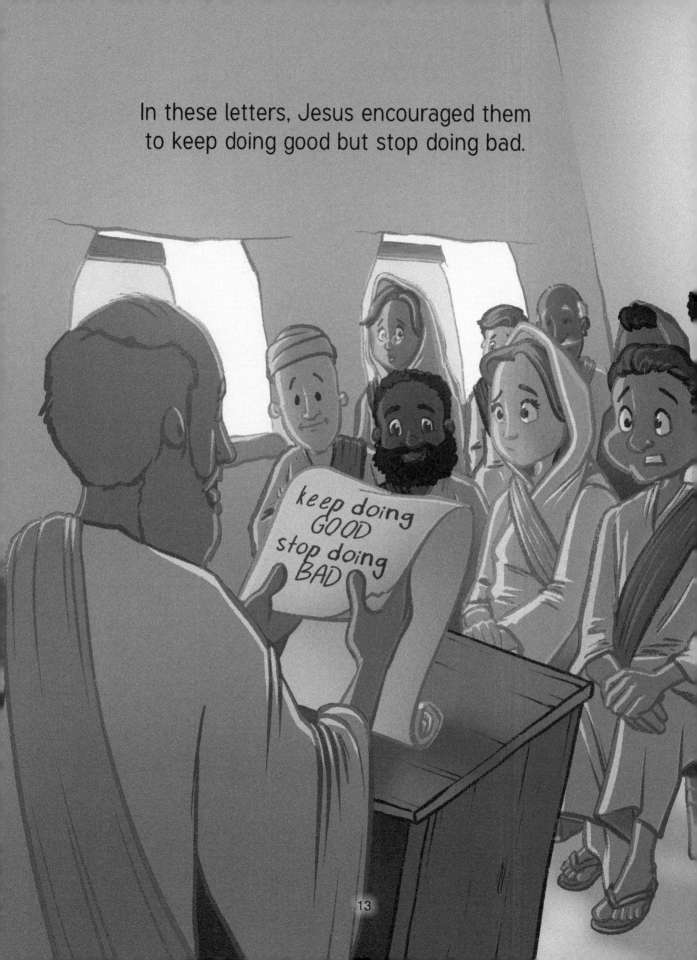

keep doing
GOOD
stop doing
BAD

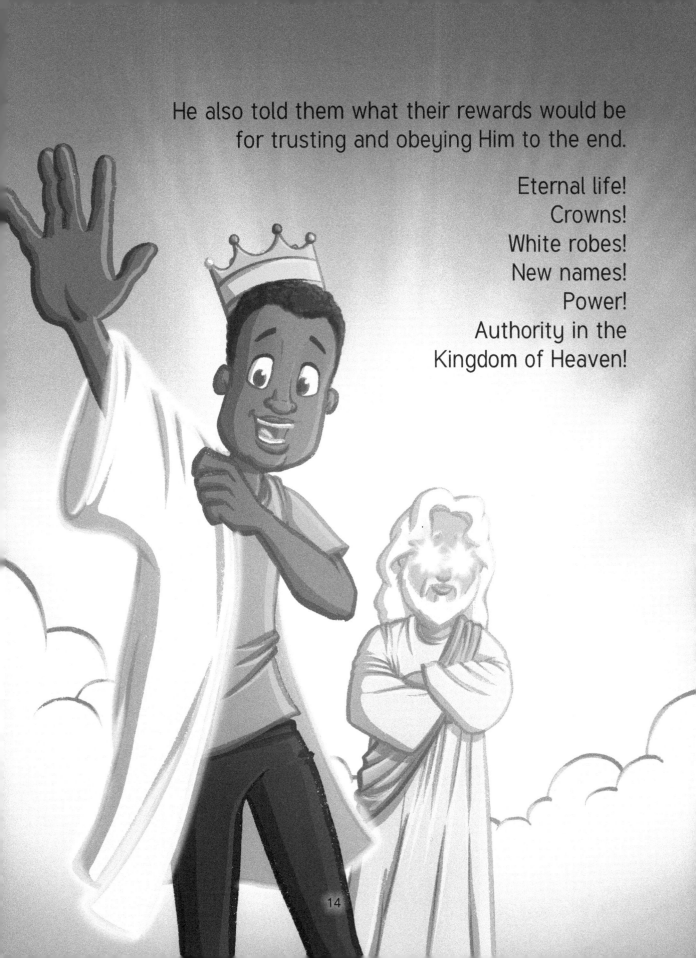

He also told them what their rewards would be for trusting and obeying Him to the end.

Eternal life!
Crowns!
White robes!
New names!
Power!
Authority in the
Kingdom of Heaven!

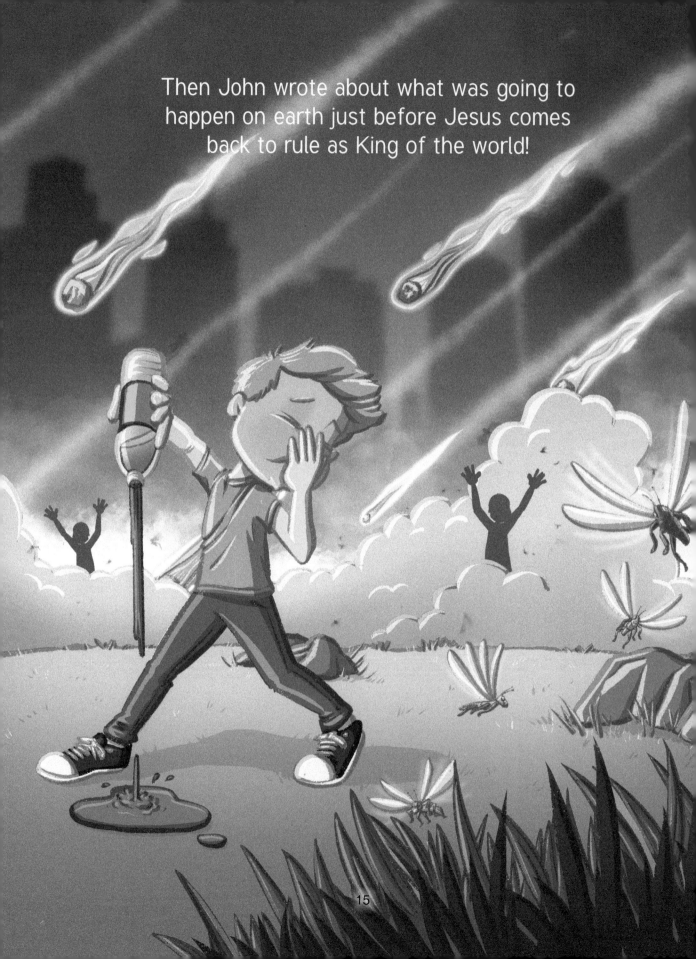

Then John wrote about what was going to happen on earth just before Jesus comes back to rule as King of the world!

He wrote about how evil would become so great on earth, and the people who loved Jesus would be treated so bad—but not to worry. God had already planned perfectly how to deal with it.

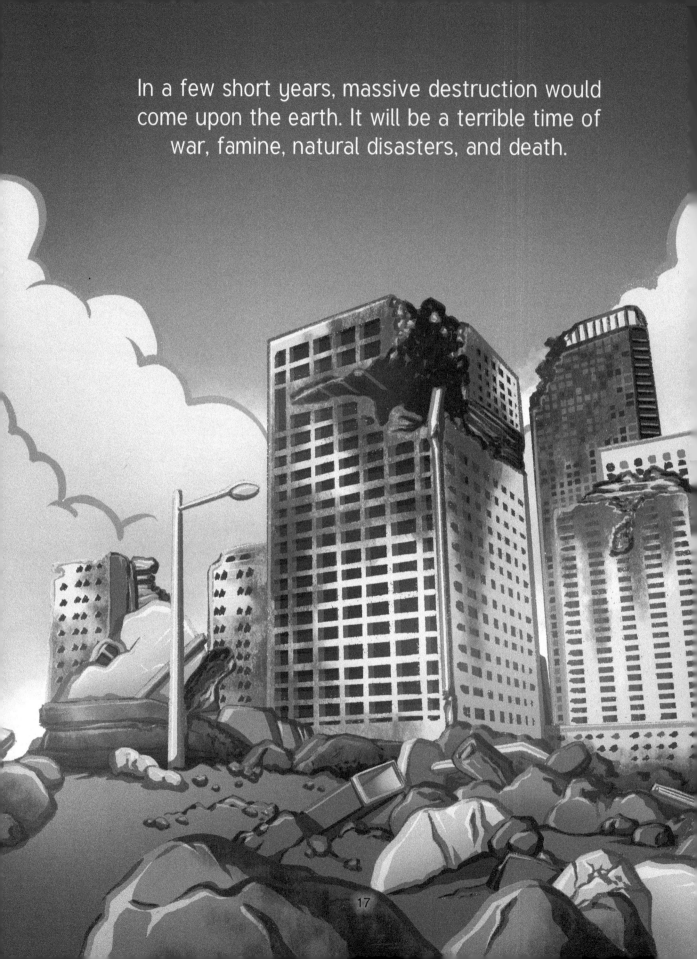

In a few short years, massive destruction would come upon the earth. It will be a terrible time of war, famine, natural disasters, and death.

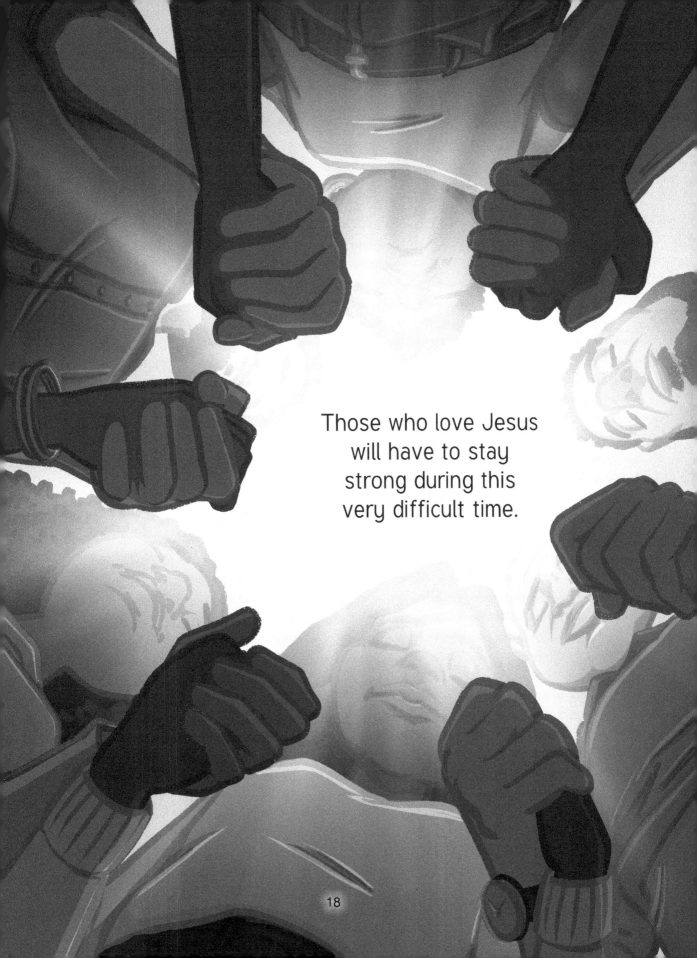

Those who love Jesus
will have to stay
strong during this
very difficult time.

But the story doesn't end there!
John kept writing, and the story continues with some really good news!

In fact, it's GREAT NEWS, the best news EVER!

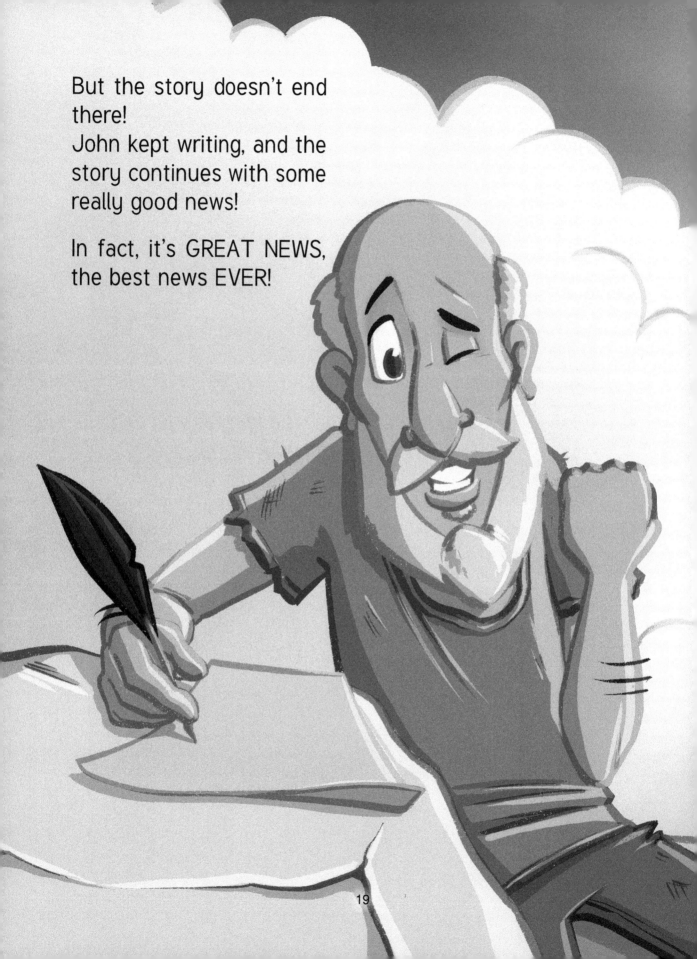

19

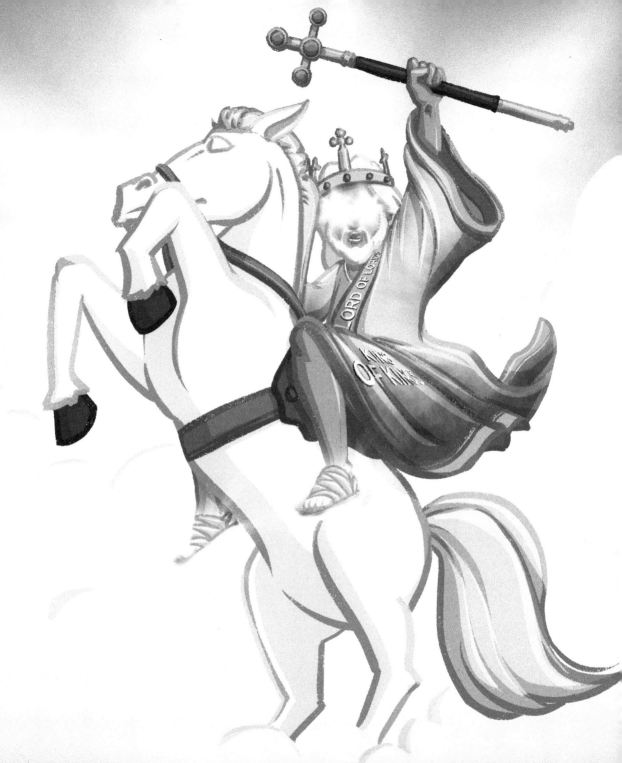

Jesus returns to earth, not like He did as a baby on the first Christmas Day but as the best King there ever was, a King of great power who will bring peace and justice and goodness!

This awesome time on earth will last for

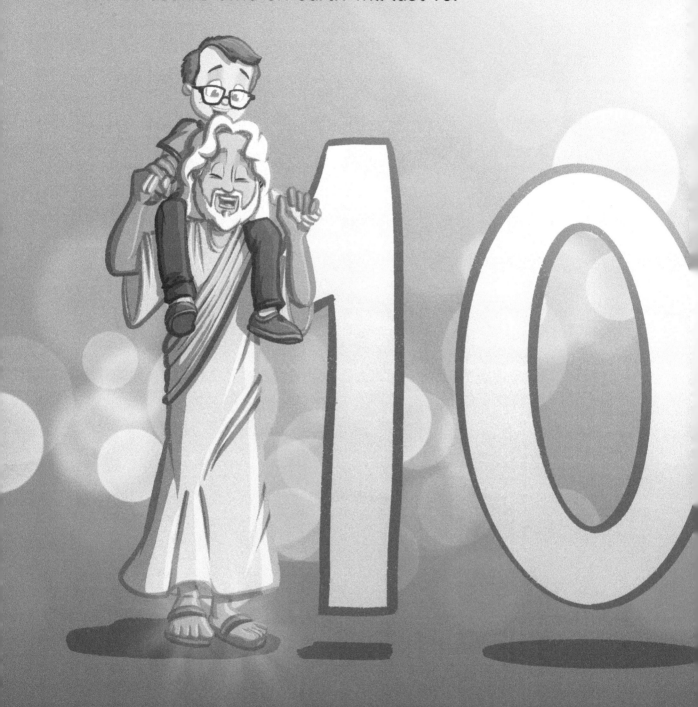

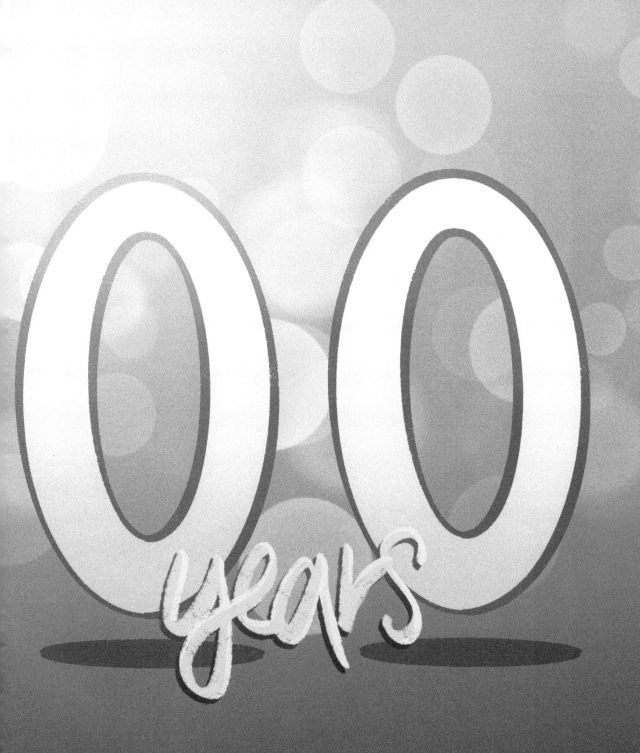

But once again, Satan will lie to the people on earth, and many will join together with him to try to destroy King Jesus. They will plan a great battle against Jesus and His army of peacekeepers.

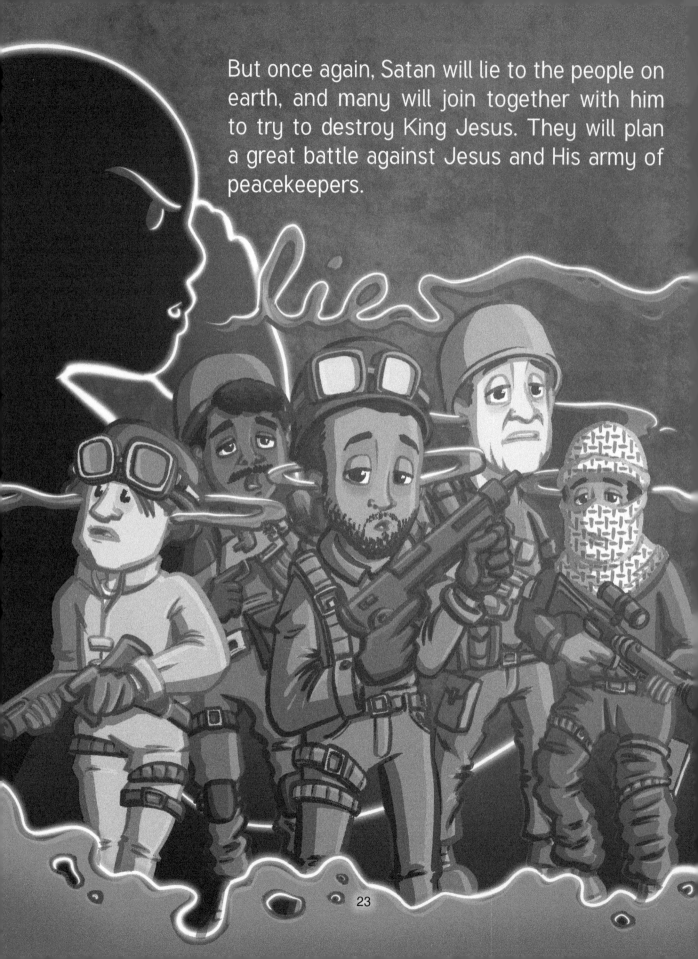

But Satan is no match for King Jesus!

When King Jesus sees the battle begin, He will end it immediately!

BAM! BATTLE OVER! JESUS WINS!

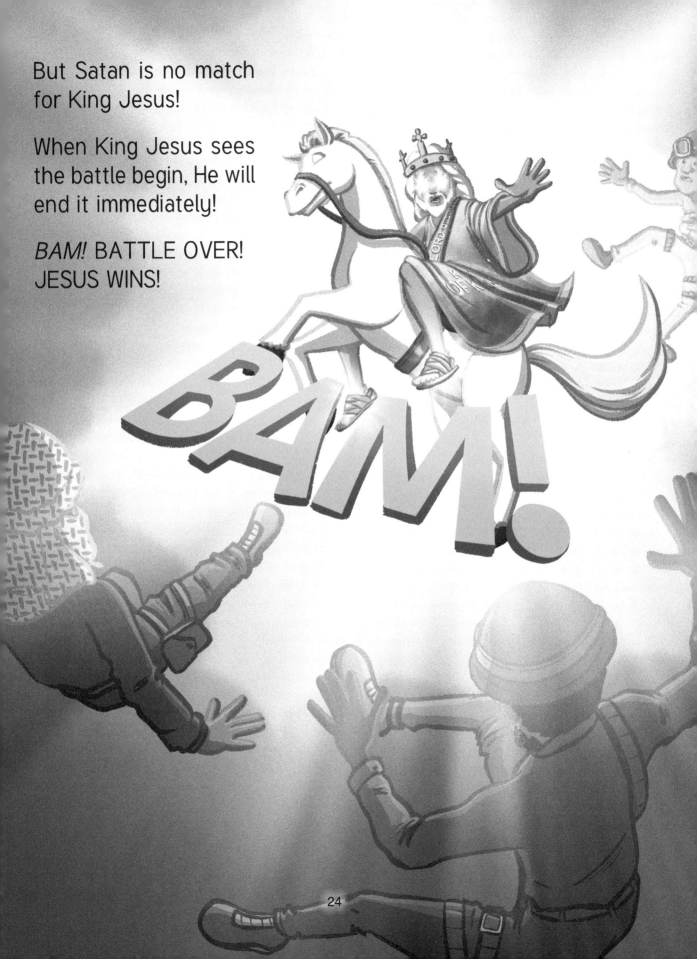

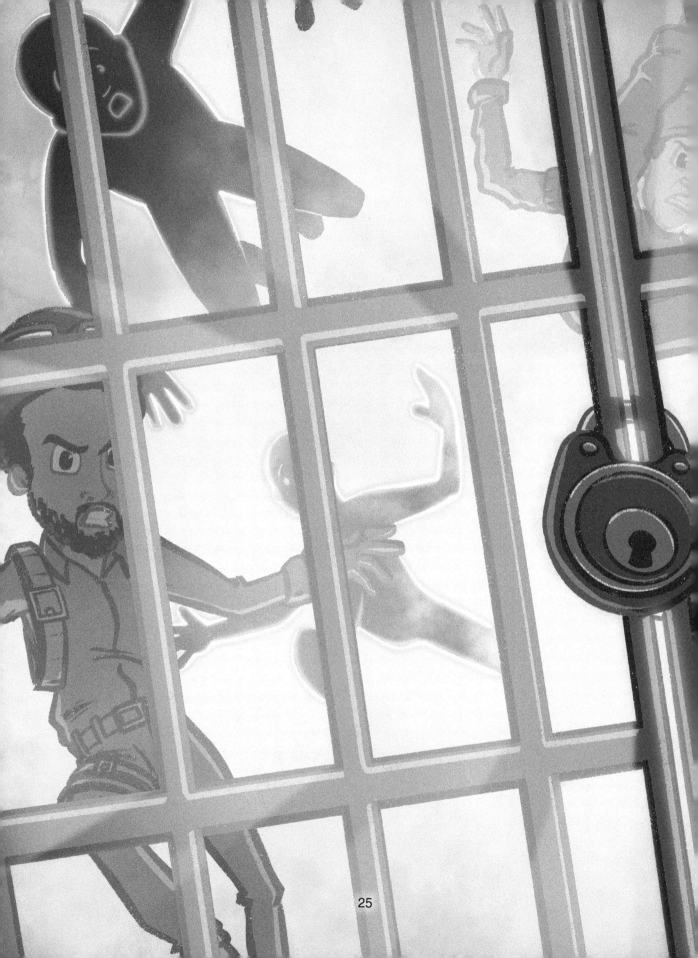

25

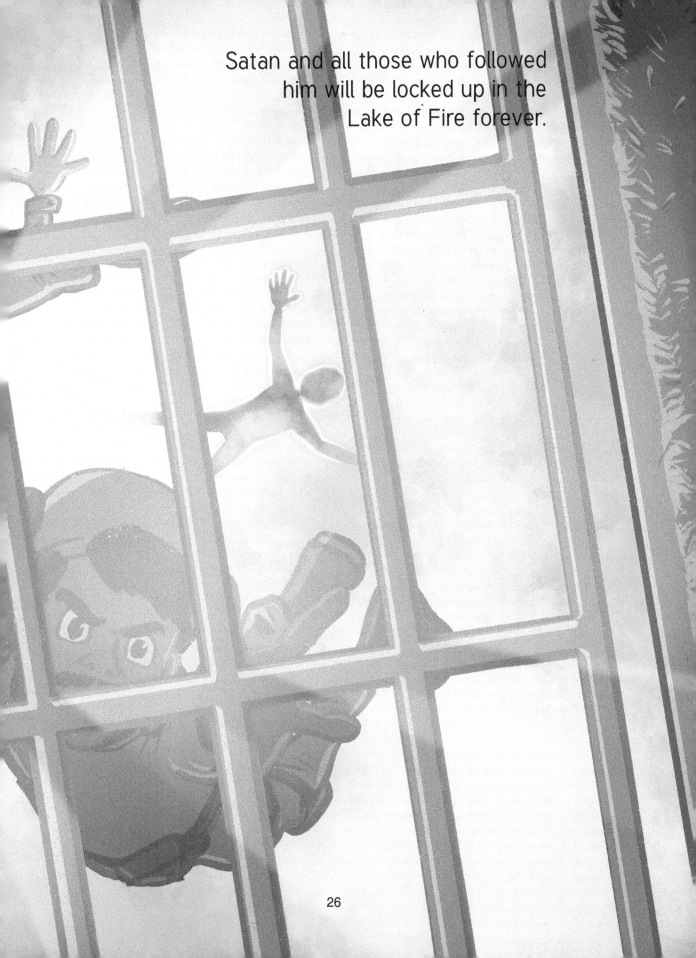

Satan and all those who followed him will be locked up in the Lake of Fire forever.

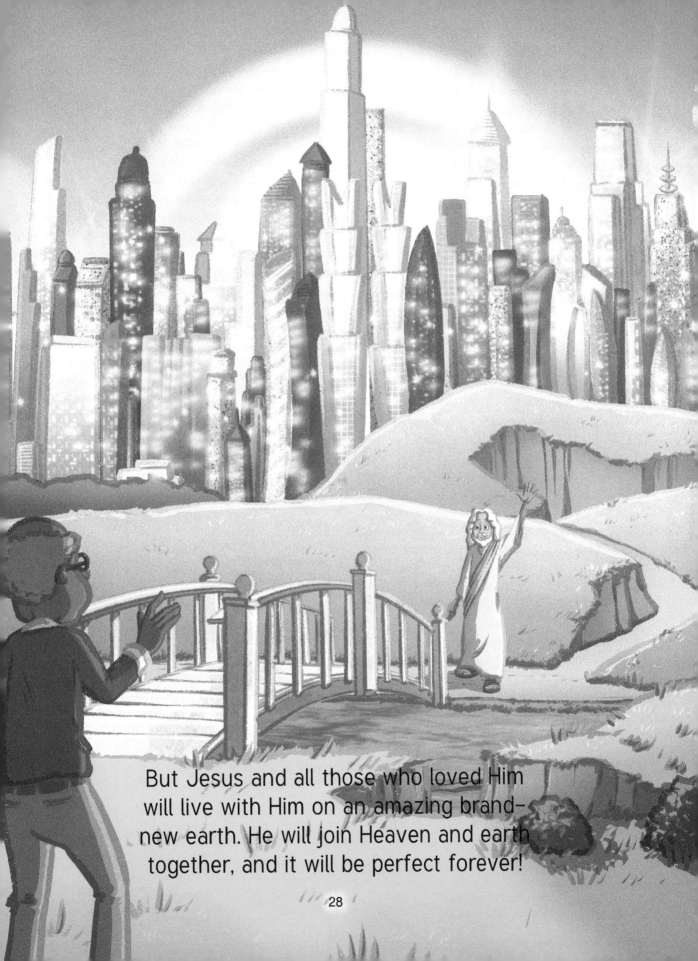

But Jesus and all those who loved Him
will live with Him on an amazing brand-
new earth. He will join Heaven and earth
together, and it will be perfect forever!

28

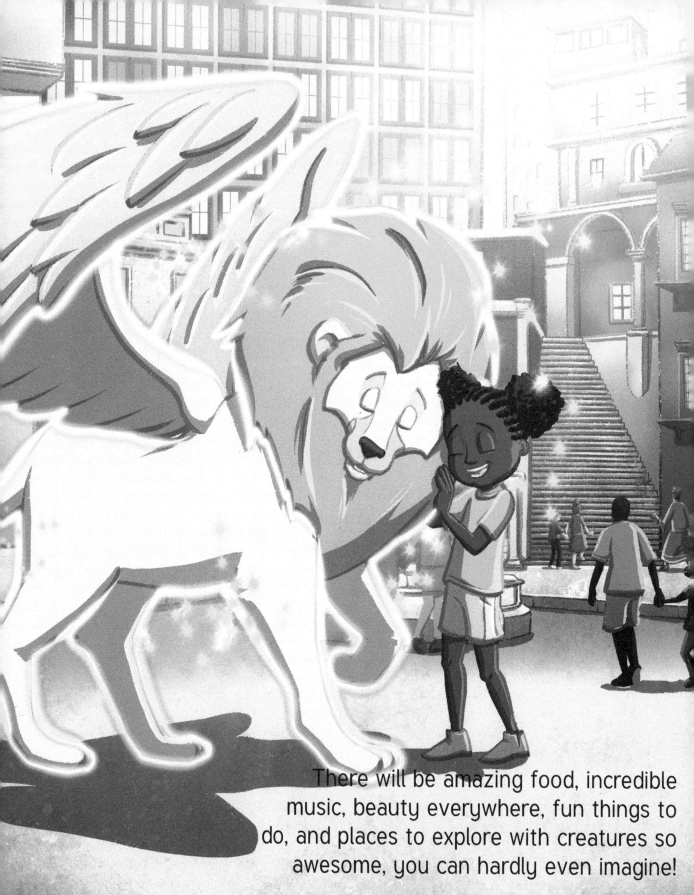

There will be amazing food, incredible music, beauty everywhere, fun things to do, and places to explore with creatures so awesome, you can hardly even imagine!

Because John loved and obeyed Jesus and wrote everything down as he was instructed, we now have this amazing prophecy to give us hope and to share with others.

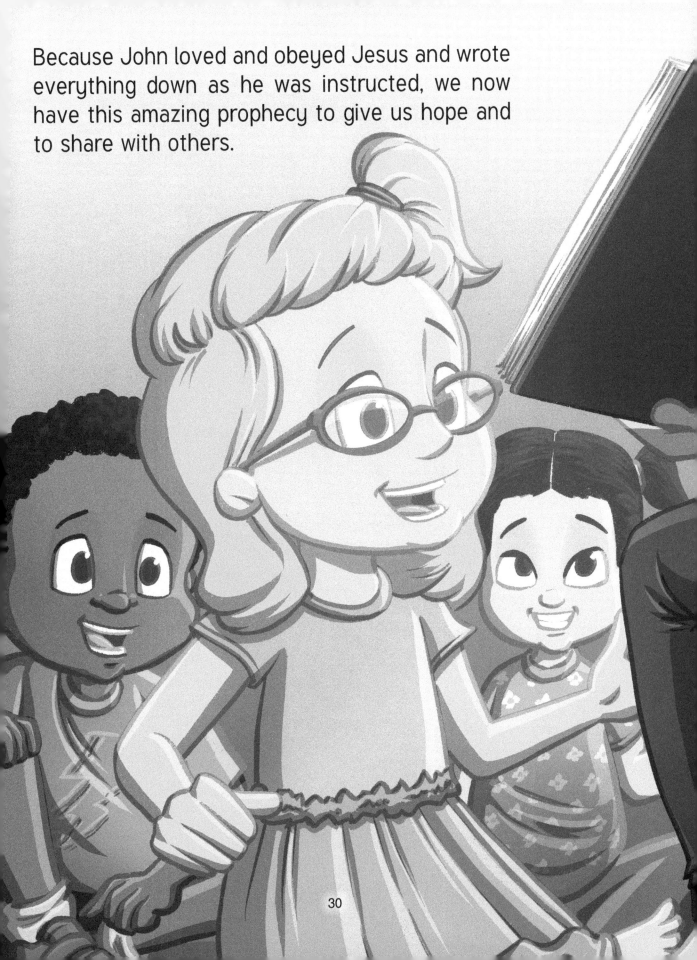

And now we know that even though there will be some pretty terrible times in the future on earth, we can also be certain that evil will one day be locked up forever.

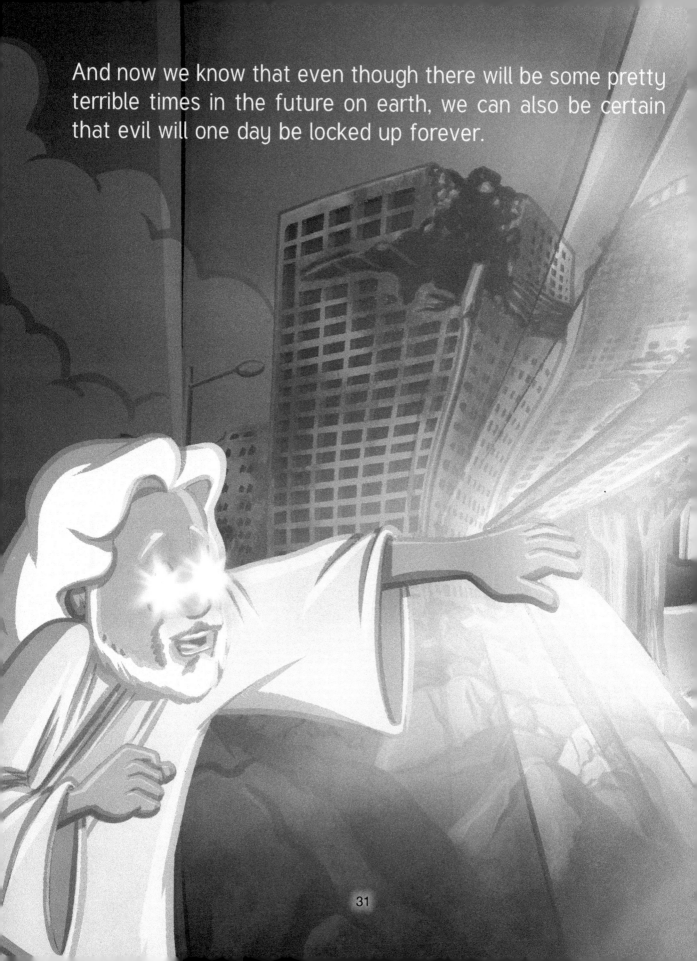

And those who love and obey Jesus will live joyfully in the most fantastic, beautiful, amazing New Earth forever and ever and ever with Jesus as our King!

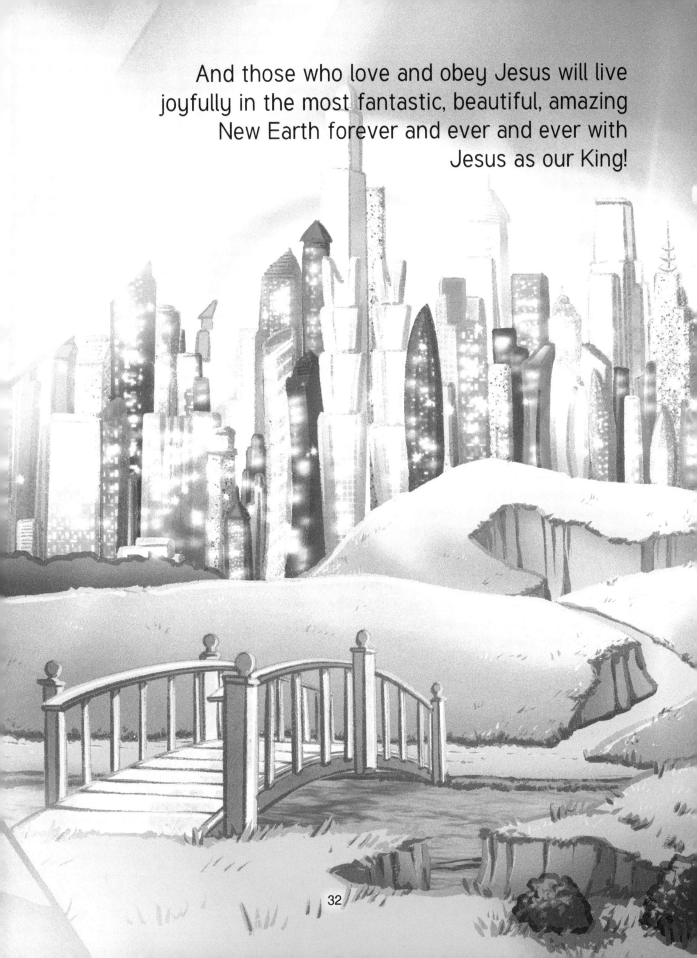

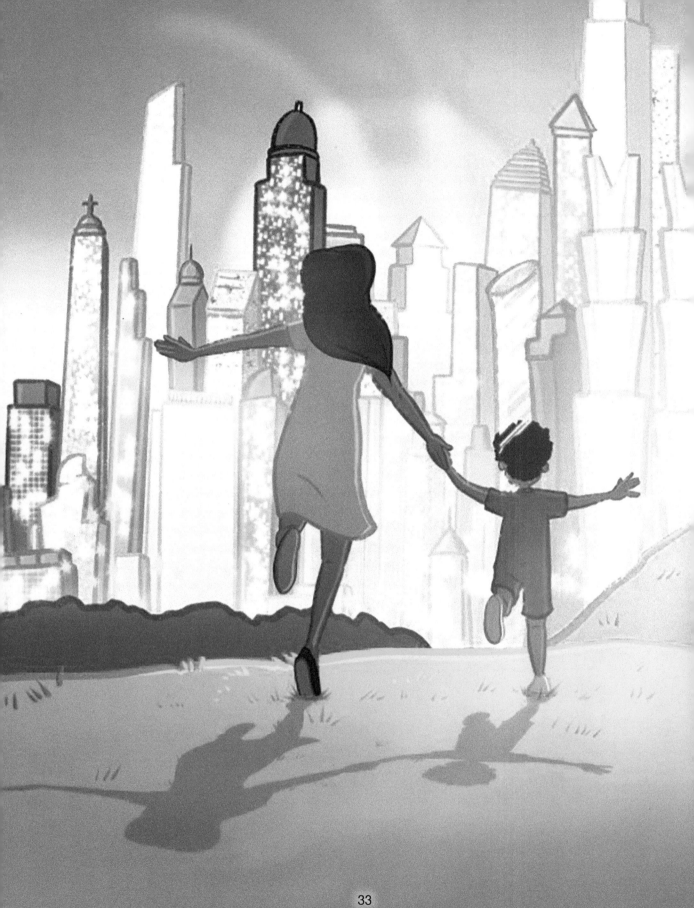

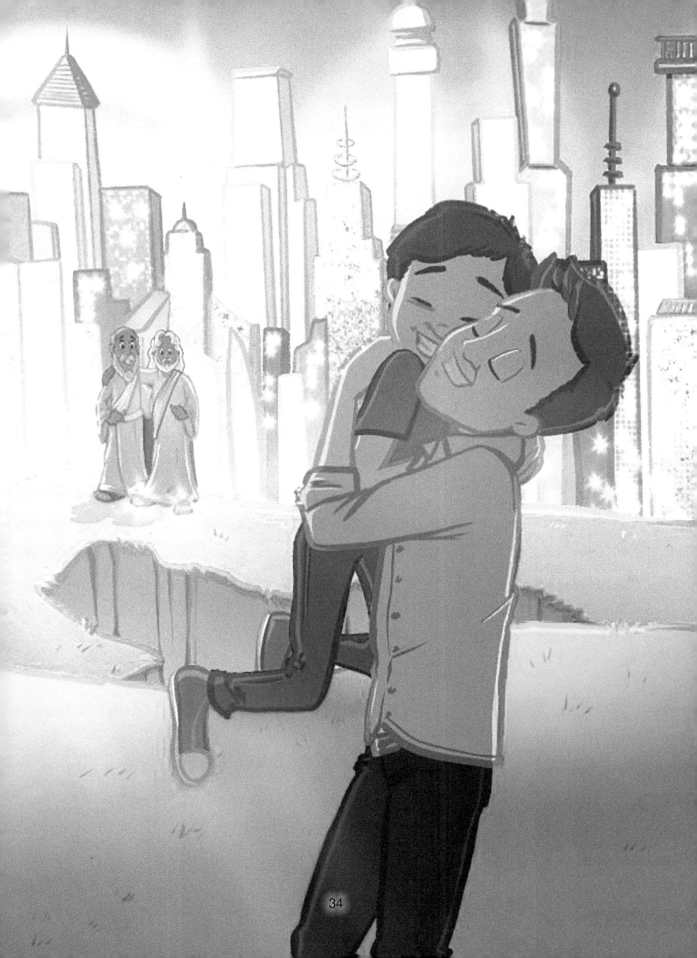

Milton Keynes UK
Ingram Content Group UK Ltd.
UKHW052242271123
433360UK00003B/122

9 798888 321294